A SARDINE STREET BOX OF TRICKS

HOW TO MAKE YOUR OWN

MIS-GUIDED TOUR

ON MAIN STREET

A handbook for making a
one street 'mis-guided tour',
identifying your significant street,
mounting your walk
and collecting your own relics.

Crab Man & Signpost

Published in this edition in 2012 by:

Triarchy Press

Station Offices

Axminster

Devon EX13 5PF

United Kingdom

+44 (0)1297 631456

info@triarchypress.com

www.triarchypress.com

ISBN: 978-1-908009-57-9

A catalogue record for this book is available from the British Library.

Contents

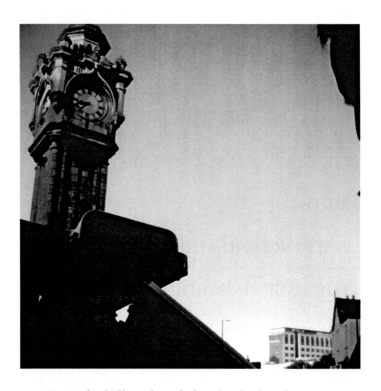

As a clock I've placed thee in the land,
To let them know how every hour stands.
Now the hours fast are hastening on
Thou must let them know what will appear
…The Serpent's curse foretells how I do warn
In the beginning there the Promise stood
And my avenging heel shall make it good."

(Adapted from *Joanna compared to a Clock* Joanna Southcott,
Unpublished Manuscripts, 1795. See ref. page 73 of this book.)

This is a handbook for making a one street 'mis-guided tour'.

There is help here for identifying your significant street, mounting your walk and collecting your own relics.

WHY?

Because our cities are increasingly policed, militarised and made banal. Because there is a conspiracy of boredom against cities. Because the Great God Pan is long dead and we still don't have the new myths we were promised. Because the city is chopped and parcelled up like a rack of meat, streamlined for ignorance and meaninglessness. Because hidden inside the functionality of the city are the secrets of texture and the funny ghosts of pattern. Because the purloined symbols of the city are all still available for us to steal back. Because the self-possession of the nonrich has always been a work of imagination, and it needs to be practised to be retained. Because of the erosion of public space. Because there are accidental playgrounds and launch pads and caves. Because of violence, property, loss and neglect. Because we are mobile and we want a fine time. For the sake of remnants and traces. To be prepared and spontaneous and happy whenever we need to be. And because we are prepared to be spontaneous. Right now...

WHAT?

Pretty much every day of our lives there's one street we walk up or drive down. It's a street that 'everyone' uses – sometimes just to get somewhere else, sometimes for its services (shops, post office, bank, mosque, cinema), and sometimes it's a place to take visitors to gaze at some part of.

But most of the time we take that street for granted. It's a retail opportunity or a motorway or a place for a stroll, depending on which of your selves you are exercising at the time. And dependent on the permission of those who aspire to control the street.

In a small town there may only be one street like this. In a big city, perhaps hundreds. Whichever it is for you, this book is a box of tricks to help you rediscover one of these streets in its multiplicity, to put those many meanings together and to show them off to friends and strangers, turning these streets into their own limited-myths and sharing them around.

The 'you' we have been writing about may be one person who wants to make their own walk, or 'you' may be two friends, or 'you' may be a professional theatre group, or 'you' may be a voluntary community group or 'you' may be an

organisation of activists – whatever 'you' you are, you can make your own tour.

This book is your ally in a struggle against retail and heritage industries that carve up the big streets: "here are the shops (buy!), here's the old bit (swoon!)…" It will share ideas about how first to break down the broken street even more and then how to interweave the slivers of meaning according to a mythogeography of the street. There may be some bending of art in all this, but there will be some plundering of politics too.

As well as a book of instructions this is also a story; of our own making of mythogeography on our chosen street.

And, this time, we have been encouraged to take the lid off our box of tricks and share our methods as well as our results. We hope that our many mistakes and our minor breakthroughs will help you draw the lessons you need to make your own street mythogeographical.

"FIRST CATCH YOUR STREET…"

It was a bright, sharp morning in November 2007 when we – that's the **Signpost** (Simon Persighetti) and the **Crab Man** (Phil Smith) – set out to 'drift' across the city of Exeter (UK) in search of a site on which to make a new intervention in the city.

For the previous ten years we had been taking destination-less exploratory walks (what the mid-twentieth century *situationists* called 'drifts' or 'dérives'). Some were local wanders, some led us far from home – in Europe, in China, in Africa. As members of **Wrights & Sites** we created 'mis-guide' books to encourage others to go on wanders of their own and made various kinds of interventions along our routes; from performances to subversions of guided tours to provocative signage.

By the time we set off on that morning in 2007 we had decided to try something different – to take our time – to spend at least a year on and off preparing a new project.

We began that day by meeting at the Dinosaur Café, a small, friendly Turkish-run eatery at the northern end of Queen Street which bears off towards the centre of Exeter. From there we set off across the city. We each carried a pole to

which were tied many labels, each bearing the symbol of a sardine. Although we did not know what our year-long intervention might turn out to be, we wanted at least some part of it to have the quality of a procession. So we had borrowed the sardine from Goya's painting 'The Burial of the Sardine' which portrays a traditional mock funeral procession, replete with satirical funeral oration and still enacted today, when models and banners depicting a sardine are either burned or buried to mark the last day of Carnival. Carrying the sardine was the mark of a promise to ourselves to attend to (and tend) the smallest and seemingly most insignificant things of the street.

Although our investigations that day ranged across the centre of the city, at the end we returned to our starting point: Queen Street. It was here that we had found inviting opportunities and affordances. It was here that we had entered a narrative flow that we had not found elsewhere.

We agreed that for at least one day each week we would spend time on Queen Street, exploring, researching and preparing to intervene.

What follows is the story of how we put together a 'tour' of our 'Sardine Street' and shared it with others, and the tactics, tricks, short cuts and ideas that we think you might find useful in making your own.

TACTIC

Choosing: to find the right street, you need to be hyper-sensitised to the flows, stories and textures of what is around you. Probably the best model we have for this is the situationist 'drift': these are aimless wanders (walks without destinations), in which walkers allow themselves to be drawn along by atmospheres and ambience, attending to their emotional responses to the places they pass through, mapping the city not for its property or traffic or cultural identities, but by feelings and associations. There are plenty of resources online and in book form that describe psychogeography (this hyper-sensitised mapping of the city). Once you feel you have a basic grasp – and no one is an expert – set off.

For tricks, exercises and tactics for good drifting, see *An Exeter Mis-Guide,* Wrights & Sites (Exeter, 2003), *A Mis-Guide To Anywhere,* Wrights & Sites (Exeter, 2006), *The Lonely*

Planet Guide To Experimental Travel Rachael Antony & Jöel Henry (Lonely Planet, 2005) and *Mythogeography*, specifically www.bit.ly/MGstart

For a good background to psychogeography, see *The Situationist International: A User's Guide,* Simon Ford (Black Dog Publishing, 2005) and *The Bureau of Public Secrets,* at www.bopsecrets.org

R & D

As it turned out, our preparations on Queen Street lasted almost three years! (Don't worry, you don't have to be as slow as us.) In that time we repeatedly explored our street in the same way we had 'drifted' the city. We allowed ourselves to be pulled by its atmospheres. We explored it with an exaggerated intensity. We examined the cracks in its concrete and the moulds on its walls, we noted its graffiti (and their appearances and fadings), collected its detritus and observed how its pavements were used and abused. We people-watched from its cafés. We chatted to passers-by and we bought small items in the retail outlets. We answered questions and we recorded stories, we asked advice. But we also did some 'desk research' too; reading local history books and searching online for information about the street and followed tangential trails of information from its prompts.

We sought out the different viewpoints of the street, from the concrete to the associative via the documented and the imagined. We scrambled down steps and through bushes, we craned to see over walls and we set off at tangents to search the street's hinterland for clues. We were discovering things all the time; that this long straight flat road is built across a hidden valley

and that in some parts, if we scuttled down side alleys or steps, we could see where it was shored up with rock and brick. That the long elegant terrace of cream coloured offices had been built as a suburban escape for the wealthy from the cholera-infested city centre of the early nineteenth century. That a man (he told us himself) had once been pursued down the street by a poltergeist from the cellar of a pub near the Cathedral. That the florist's on Queen Street plays something like a magick role at the city's rites of passage. That the 1970s-built telephone exchange had strange corner windows that would double as machine gun positions in the event of war or revolution. That a small tomato plant growing in the pavement outside the Dinosaur Café (with fruit!) had, Abdullah guessed, sprouted from a seed fallen from a plate of fried breakfast.

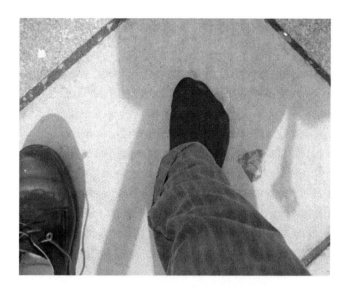

There was no exactly predicting where or how
we might find the most useful impressions and
information. Sometimes the source was a
document: research online turned up the street's
eighteenth century prophetess - Joanna South-
cott – which led us to the works of her predeces-
sor in apocalypse, Richard Brothers, and his
plan for a reconstructed Jerusalem, which in
turn directed us to a freemasonic temple tucked
to the side of Queen Street. Sometimes we were
supplied by accidents: one cold morning a
businessman rushing to a meeting lost the sole
of his shoe and jerked about at the shock of the
cold concrete suddenly felt through his thin
sock. On another day we stumbled upon the

formal closing of the city's museum for years of refurbishment.

By choosing a street close to our homes, we were able to put in short bursts of research on the street. We stopped seeing the street as a series of snapshots; instead it became an endless movie. We took our time, avoided burn-out from any sudden rush towards performance, just putting in a few hours now and then. We became part of the street's regular life, we began to feel how different elements of the street related to each other, to feel its longer rhythms, and to be able to weave more tightly the fragments we had found. (Having said all that, in the past we have put together 'mis-guided tours' in a very short time, sometimes less than a day; so, all this might be experimented with at great speed.)

From early on, we decided that our intervention should take the form of a 'mis-guided tour'; that we would take people on our own version of a guided tour of the street, while subverting the format of the 'guided tour' by exposing its (and our) prejudices and limitations, questioning the way that the meanings of any such tours are produced, channelled and restricted. Once we'd settled on our 'format', we began to morph our costumes, actions and scripts. Eventually we would wear blazers with stitched pocket badges

that represented our personae: the **Crab Man** who is always crabbing off sideways down alleys, and the **Signpost** who points away from psychological interiority to the ambience of place and the political and erotic charge of the pavement slabs.

Again and again we walked Queen Street, each time changing a little more from exploration to a hybrid of searching and rehearsing together. The material we amassed became ever more detailed and interconnected. After a few months we began to invite friends to come along with us, and informally we guided them along a portion of the street. On these occasions we invited people to bring along something they might

use (or to be prepared to deploy some skill they might have); on one occasion we were treated to an impromptu concert in the piano shop. On another, our little party attracted the attention of a chef from the street's Rougemont Hotel who promptly invited us in to see the remnants of late eighteenth century prison cells among his subterranean kitchens.

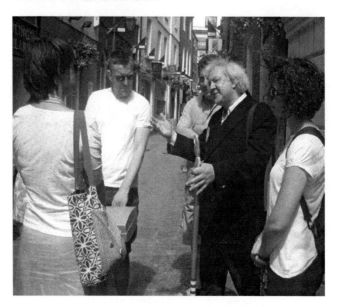

TACTIC

Everyday performing: from the very beginning make yours a very public investigation. From the start wear something that sets you apart and gives others permission to approach you:

"excuse me, what are you supposed to be?"
Or: "what are you doing?" Your responses (be
truthful) may well encourage your questioners
to share their stories of the street with you. The
moment you begin to gather these stories then
carry some representation of at least one of them
– so, when someone gives you a story you have one
to perform for them.

WALKING AND THINKING

Much of our recent professional and informal practice has involved performing en route; we have taken part in numerous walking projects and performances. But we discovered a new guiding principle while working on 'Sardine Street' and that was 'repetition' – we walked that same stretch of street again and again and again. This was never boring. It led us to ways of working that we had not attempted before and dramaturgical results that we had not expected. We not only became commentators upon the life of the street but we became part of what we were commentating on. We came to recognise an ethical obligation to our site; something characterised by Melanie Kloetzel and Carolyn Pavlik as "attending to place" – not only 'paying attention' but also 'tending'.

TACTIC

Set yourself tasks – for example, using long pieces of rope we measured the lines of fire from the machine gun positions in the telephone exchange. If you set yourself tasks that passers-by will be intrigued by, they will enjoy interrupting and even joining in with you. If you want to put some ideas behind this participation – try *Relational Aesthetics*, Nicolas Bourriard (Presses du réel, 2002).

Everything we did was informed by our idea of 'mythogeography'. This had been developed through Wrights & Sites, and tested out in partnership with many others. Mythogeography is a series of approaches to space and place that attempts to reveal the multiple meanings in any site and to set the ideas, feelings, symbols and discourses of these places and their people in motion about each other.

To this end, we repeatedly 'processed' along Queen Street. We adopted the street as a zone of encounters; an affordance for meeting with the street's workers, walkers and inhabitants; we became the temporary keepers of a living and ever-changing archive as we amassed stories and discarded, lost and bought things.

Over many walks as a duo and then, later, with our invited guests (and sometimes uninvited ones), we built up a proto-script of the street based upon factual, journalistic and associative events. And we preserved our contemporary relics taken from the gutter and under the bushes; we sought to amass an archaeologised resistance to the present through the markers of the very recent past, the splinters in the urban skin.

THEORY

The ideas of mythogeography arose from the attempts of Wrights & Sites to make performances in places of tourism and heritage and their shock at the ways that meaning in such sites was fiercely policed and limited. Mythogeography is all about finding and expressing the multiple meanings of any place.

> "3/ mythogeography is a philosophy of perception, always a mobile one; it is a thinking that allows the thinker to ride the senses, and to use those senses as tentacles actively seeking out information, never as passive receptors of it; perceiving not objects, but differences.
>
> 4/ the space of mythogeography is neither bounded nor sliced by time, but is made up of trajectories, routes, lines of journey and cargo. The places of mythogeography are defined by the reach and roundabouts of their commerce, traffic, interactions and solidarities. It aspires to a new, mobile architecture of exchange where strangers are changed into friends."

From The Mythogeographical Manifesto, p.113 of
Mythogeography (see below).

For plenty of detail on the ideas and tactics of mythogeography try either *Mythogeography*, Phil Smith (Triarchy Press, 2010) or 'Crab Walking and Mythogeography' in *Walking, Writing and Performance,* ed. Roberta Mock, Intellect (2009).

"The next thing to be done was choosing the other members of the expedition. We did not anticipate that this would cause us any great difficulty, as we knew that there were thousands of men and women in the world who were – like ourselves – tired of leading a dull, artificial life full of conventions."

From *The Ideal Island*, C. V. A. Peel

Meeting people at the Dinosaur Café.
***Signpost** & **Crab Man** enter the café. They are carrying a large gold-coloured box. They wave to the waiting walkers, and collect pre-ordered espressos from Ayse, then join the walkers.*

Signpost: Hello.

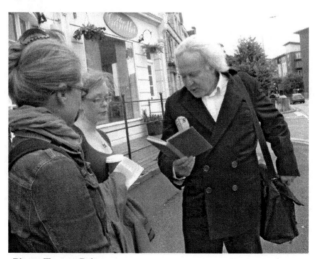

Photo: Tamany Baker

Photo: Tamany Baker

Crab Man: Hello.

Signpost: I'm Simon Persighetti. But for the journey I'm the Signpost.

Crab Man: And I'm Phil Smith and I'll be the Crab Man. We can relax for a minute, finish our coffees and then we'll go.

*(Chat. Finish coffees. **Signpost** is creating the Ideal Island on the table – using pepper pot as a tower and sprinkling salt around it to represent the sea.)*

Crab Man: OK, we're almost ready to go. Most journeys begin with the idea that something will be better or at least different by the end of them – whether a pilgrimage to a holy place or a trip to the corner shop to get... I don't know... a tin of sardines.

Signpost: But we're asking only that you make a promise that one day you will take someone on a walk. OK?

Crab Man: And that can be a very simple walk... it doesn't have to be a prepared event like today.

Signpost: If so, would you make a mark in the salt?

(The walkers are free to make a mark in the salt.)

Crab Man: And now we're going to show you some of the secrets of this one street, but everything you need in order to discover these secrets is in the street itself.

Signpost: For there is always another city in the city.

Crab Man: And a shadow of that city, for right here two dreadful utopias were conceived. One, for an "Ideal Island" far away. And another, for the salvation of this island under threat.

Signpost: Every pilgrimage has its burden: utopia is ours. We'd like you to help us carry it.

(Signpost pats the sealed gold-coloured box and Crab Man asks the walkers if they would help by carrying it, handing it over to whoever volunteers to carry it first.

Photo: Tamany Baker

*Then **Signpost** scoops up the salt into a small container and gives it to **Crab Man**.)*

Signpost: Let's go. *(Leads the walkers out of the Dinosaur Café.)*

TACTIC

Interaction: From the very beginning, we were interested in making our audiences participants in an active relationship with the many layers that we were turning up and that were drawing us in. We wanted to share the journey by asking others to come and work through these layers with us.

Photo: Tamany Baker

We wanted people to join us in the encounters
and explorations that were triggering the expo-
sure of relations and 'power geometries', and
turning up multiple narratives in spaces where
there were always changes to be encountered
and new events to be addressed: an ailing home-
less man left to die, the tomato plant emerging
from the pavement crack, the line of concrete
bollards smashed by a crashing car. Our audi-
ences were challenged to respond to and enjoy
the street: through offers and instructions, maps
and burdens, gifts and libations. They carried,
drank, tasted and scrambled. They held, touched
and ran. About a third of the way down the
street we sent them off with a simple map to
walk a short tangent on their own – to give them
a rest from our voices, allow them to bond a

little, and to bring them back to the street with fresh eyes. We invited them to play hopscotch, to run like Roman soldiers and to mimic stalking an elephant through an African jungle.

The street is our library. But the library is also full of walks.

(But we sometimes missed opportunities – when we donned false moustaches to become big game hunters, we were later told by one participant that she was sad we didn't give all the audience moustaches to wear. Next time we will.)

In turn, we attempted to respond to the audience's responses (and those of passers-by), both in the moment and by working these responses into later performances. (At one point we used some concrete slabs that looked like book spines

to chalk the names of key authors on walking –
like *Pilgrim's Progress* by John Bunyan, *Occasional
Sights* by Anna Best, *Spiritual Compass* by Satish
Kumar, *The Theory of the Dérive* by Guy Debord,
Black Woman Walking by Maureen Stone, *For
Space* by Doreen Massey, *The Gentle Art of Tramp-
ing* by Stephen Graham – and we asked for new
suggestions.

Some of these suggestions became part of our
regular list in later tours. We tried to make the
interests of the planned walk secondary, and
always accept the chance to make something
new.

THE TOUR OF SARDINE STREET

Now we are going to break the story of our tour into two parts. We are doing this because the story is far less important than what you can take from its bits. First, we will list some of the key qualities of our tour – for which you might find equivalents on many streets.

Each of these elements arose from, or was detected by, a tactic, a trick, a certain kind of awareness or an openness to chance opportunity – and all such preparations you can use yourself.

Second, we will describe the myth we made – the way that we wove together certain aspects of Queen Street to create a Sardine Street myth.

But first things first...

THE ELEMENTS

• Intensive research

If you want multiple layers and diverse elements then adopting different kinds of research may help you.

Find out all you can about the history, the geology and the architecture of your street. Much of that finding out may be fairly conventional: online, in libraries. But don't scorn the naff sources: check out the local book of ghosts and legends. Then there's just being on the street. And chatting.

Vary the ways that you are on your street.

Walk the length of it quickly and see what narrative you can detect.

Try a 'static drift': choose a spot to sit and let the street come to you.

Or choose very limited areas – a few square metres, a footprint – and examine them in obsessive detail.

"He adopts a paving stone, perhaps on his street. On a regular basis he uses this site as a canvas or page or material to write upon, or inscribe upon it, or act upon it, or to leave some object to be taken away by unknown passers-by or by the road sweeper. Sometimes he may simply wash the stone or plant seeds between the surrounding cracks. He supposes there may be times when he might be accused of vandalism. He would have to decide between actions of permanence and impermanence, durability and disappearance." (Simon Persighetti, 2001)

• Layers

If you imagine that you are archaeologists of the meanings of your street, then your walkings are a series of excavations, and your discoveries are part of more than a single story; they are relics resting between colliding layers of significance.

There were many different layers that we discovered – some obvious, some only emerging after months of looking. There was the geological layer, the layers of various architectures (connected to a temporal layer), there were the layers of rubbish and the coatings of grime, a layer of accidents (one set of paving slabs looked like markings for hopscotch) and layers of secret use (we knew that Royal Marine Commandos

practised *parcours* in the Exeter streets after dark).

(Crab Man by now has taken out a 'Dark Skies Map' and opened it at the part showing Exeter. Signpost brings the walkers over to look at it.)

Crab Man: There's no real darkness here anymore – the city recreates the light of the volcano. The laser show on the clouds only emphasises how we're disconnected from the sky.

Signpost: Yet, we walk around in the dust of other planets – 300 tons of dust from Mars falls on the Earth every year. In this street there is a small but observable layer.

Crab Man: It is the 53rd of the 365 hidden layers.

And there were many temporal layers. At the very beginning of the walk we explained that the rocks of the Crackington Formation (at the northern end of the street) were formed in oceans filled with early sharks, and that the land there had once been part of a deer park gifted to the city by King Athelstan in the tenth century.

But we are not geologists or historians – our interest is in using such factoids to generate a dreamlike and 'made-up' geography (that anyone can re-make), an urban landscape that is populated with wraiths and spectres as well as shoppers and office workers. In this regard we

trace our heritage back through the situationists to the surrealists:

*(**Crab Man** stops them just outside a door on the steps.)*

Crab Man: We have stepped into the geology. These four steps represent the four key eras:

*(**Crab Man** points to each of the four steps in turn)*

Volcanic eruption
the building of causeways
the rising of the oceans
and the birth of language.
We are about here. *(Pointing to the second step.)*

• Nigredo

Change your audience's way of being from the quotidian to the super-sensitised. You have a responsibility for their physical safety, but you also have a responsibility to assist and enable their imagination by upsetting their composure.

Hardly had we emerged from the Dinosaur Café than we plunged our participants into heavy traffic and crossed to a part limestone, part sandstone Clock Tower on an 'island' surrounded by circling cars:

Signpost: Step into the nigredo!! But be careful – don't get yourself run down by Ginsberg's Drunken Taxi Cab of Absolute Reality. It would

be unfortunate if the rubedo were to flow prematurely.

Crab Man: *(Encouraging the walkers as they cross the road.)* Step into the ocean! Leap into the waves!!

Shouting alchemical terms we attempted to shake up our audience, to scare them a little without compromising their safety. The crossing is a hazardous one as the Clock Tower makes it difficult to track traffic arriving from five different directions. Just as at the start of the alchemical process materials must be broken down to a chaotic and decomposed mixture, so we attempted to 'decompose' our participants (to shake their composure). We led them through the stream of cars to a horse trough full of green slime and harangued them with incantations to sharks and the tower's former panoptic resident.

• Costumes and characters

Use these 'in quotation marks'. Don't try to create characters that operate as if they are in a naturalistic drama. If you use characters then they should be walking symbols or stereotypes. Use costume in ways that don't simply 'dress' a character – if you are in a busy road then dress as a car, dress in paper and be litter. Wearing everyday clothes for your tour is an appealing option, but danger lies in a message they can send: that the problematical elements of the mainstream guided tour (the singularity of the expert voice, the passivity of those guided, the exclusion of elements from the route, etc.) have been solved or dispensed with. By using some trace of costume you can draw attention to the problems of 'voice', choice, expertise and direction that you are struggling with.

We chose to dress in formal dark blazers with identical custom-made pocket badges that included our crab and signpost symbols. The rest of our clothes – shoes, trousers, etc. – were everyday (jeans or slacks, open-neck shirts). In that way we tried to flag up the contradictions in our use of the role of 'tour guides' and that we were trying to be playful with its conventions (rather than propose that we were 'above' them).

We were encouraging our audience to always be a little suspicious about our intentions and to question our control of the narrative of the tour. We wanted to be clear that we could never fully escape from the problems of the 'guided tour', but that we were using the problems themselves as part of our material. It also made us look smart and gave some of our audience a good laugh when they saw us for the first time. We also each carried a gold-coloured rod or pointer (each with our symbol) and while these also played up our comic appearance, they were also very useful as pseudo-ritual objects, for extending our gestures and for pointing at things.

• The mis-guide

If a group of you are making a tour then decide whether you want to have one 'guide' figure and everyone else creating events and actions around the route, or maybe one person starts and then someone else takes over the 'mis-guide' role, or have two guides who argue throughout, or have everyone as a guide and speak as a chorus... whichever way you go, the role of 'mis-guide' should expose the problems of the conventional guide (prejudices, the anti-democratic expert, the limitation of meaning).

The two of us played 'mis-guides'. We worked in co-operation rather than competition. We did at one point attempt to create more distinctive roles for each other, but that felt contrived and we allowed our own proclivities and preferences to shape what we did.

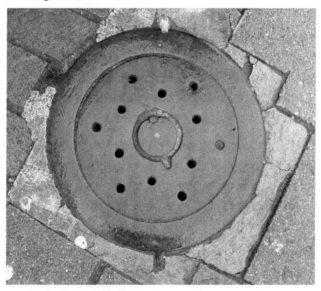

• Pseudo-ritual

While you (and we) may have no aspirations to play at shamans or priests, there are a multitude of ambiguous, secular, ironical and hollowed-out rituals that you can draw upon to complement the multiplicity of your walk with intensity of feeling or depth of engagement.

Just as 'costumes' or 'uniforms' (or some hint or token of them) can point up and remind participants that you are using elements of a social and power-inscribed role, so ironically used or quoted rituals can point up your (mis)use of certain discourses, routines, procedures or symbolic actions.

For examples of artists using such actions you might look at Marcus Coates' *Journey To The Lower World* (Platform Projects, 2005 – this book contains a dvd of the performance) or the work of Lone Twin: www.lonetwin.com/

There is a practical (and thieving) side to your use of such comic rituals: they can help you to create moments when your whole walking group works together in action. You can use them to poetic effect.

We performed a number of pseudo-rituals: we circumambulated the tower, we stirred the dank water of an old trough to invoke the reflection of a horse (and what the horse saw) and we conducted a ceremony, with the cutting of a ribbon, to rename the street 'Sardine Street'. We used one of our golden sticks to make a physical connection for the participants with the depths and heights of our street. We used the stick partly like a surveyor's ranging rod, partly like a magic

wand. First we suggested the street's metaphorical depths...

*(Arriving at the site of the former Blue Fish Restaurant, the **Signpost** uses chalk to connect up the six holes in the first drain cover into a six-pointed Star of David.)*

Crab Man: For some years this was a fish restaurant with a painted sign over there advertising their lobsters. "It's a quick death, God help us all. It is not." Some lobsters live very deep in the ocean, in niches hardly bigger than themselves. And sometimes they can become trapped in their niches, and yet some of these survive just on the food that falls within their reach. And their bodies slowly grow into the shape of their tiny homes, and at that moment they adopt the planet as their new shell. Can you adopt the planet for a moment?

Signpost: Wear the world as your shell.

*(**Signpost** and **Crab Man** encourage people to mould themselves to the walls and pavement. The **Crab Man** plants his stick in the middle of the shapes of radiating waves on the second drain cover.)*

Crab Man: From the ocean to the stars. Please put your hands on the stick and look up.

*(The **Crab Man** uses chalk to add a couple of extra radiation marks around the drain cover. Once the walkers have placed their hands upon the stick, the **Crab Man** leaves the stick in the hands of the walkers, and goes to the iron gate, where he draws chalk lines on the paving slabs, connecting some of the many discarded chewing gum pieces on the pavement into constellations.)*

Now we used the stick to point the participants to the sky. After a description of an early winter morning on the street when we saw a laser display playing on the clouds, we switch Simon for the golden stick:

Crab Man: So with the Sun in your bodies and Mars under your feet, please – just as you touched the stick – now touch the **Signpost** – for he has the Moon in him.

(Crab Man takes the stick and the audience place their hands on the Signpost. Crab Man is quietly singing the song from the final credits of the 1960s TV puppet show 'Fireball XL5':
"I wish I was a spaceman, the fastest guy alive, I'd fly you round the universe in Fireball XL5.")

Signpost: My friend R.D. the goldsmith was commissioned by a certain scientific institution to cast a special ring for a retiring space scientist...

• Autobiography

Subjectivity is always suspect! It's so easy to accuse the subjective of self-indulgence, selfishness, egotism, unreliability, special pleading. But for our work of multiplicity we value subjectivity as a de-stabilising agent which can only ever be half believed, and yet has the power and appearance of a questionable authenticity.

(You can probably tell by now that although influenced by the situationists we have sometimes backflipped over them to the dream art and absurdities of the artists and activists who influenced them and who they rebelled against: the Dadaists and surrealists.) Be sure to find a space on your own tour for some shameless reminiscence, personal or quirky association, dream or hallucination.

We tried to weave our own associations and reveries about our route into all the other strands of meaning – the histories, the geology, the cosmology, the dystopias and the commentary on architecture. Simon continued his tale, until, through his reminiscence and via his anecdote, we could all touch the Moon:

Signpost: ...The ring was to be made as a setting for a fragment of genuine moon rock. This was a unique and somewhat daunting project and so R.D. invited some friends to his studio to contribute design ideas. We all gathered and drank wine. In the centre of the room on a pedestal was displayed said cosmic relic. After some time the guests began arguing over their ideas and our host the goldsmith became rather agitated. Suddenly he shouted "Silence. This is getting us nowhere. But I think we can solve this all together."

Grasping a pestle and mortar he flipped the rock into the pot and to our horror he began grinding the stone to a powder which he dexterously sprinkled into a large cigarette paper. The rest is legend. All the guests smoked the moon and the problem was a problem no more...

*(**Signpost** holds out his hands to touch the walkers. He chants.....)* I inhaled the moon, the moon's in me, I inhaled the moon – Sheer Lunacy.

• Owning up to our traditions

There are a myriad artists whose work has drawn them to place and to site, and you should feel free to learn from, adapt and nod to their work. These artists might include land artists like Ana Mendieta, Robert Smithson or Andy Goldsworthy, artists of walking like Kinga Araya, Richard Long or walkwalkwalk, artists who animate place like Francis Alÿs, Anna Best, Mark Dion, Heather Ackroyd and Dan Harvey, geographer-architects like Stalker and Eyal Weizman, magicians like Alan Moore and his audio-workings or Jim Colquhoun, musicians like The Psychogeographical Commission, Mount Vernon Arts Lab or The Future Sound of London, sound artists like Duncan Speakman and Janet Cardiff.

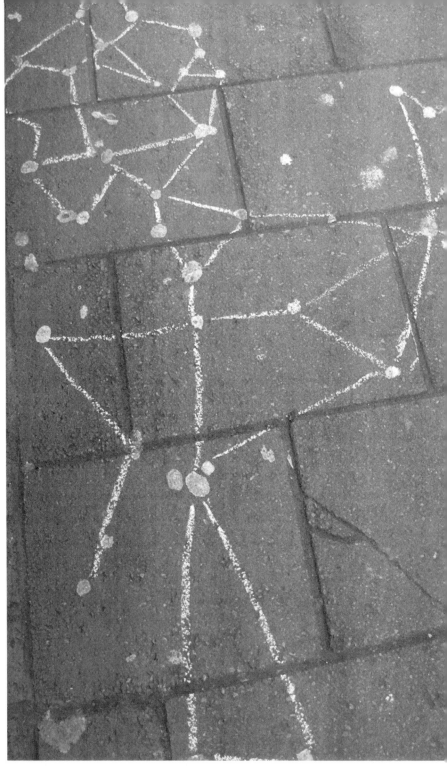

On our Sardine Street Tour we remembered the video art work of the Brazilian artist Ducha who pretended to accidentally drop a large bagful of oranges among pedestrians and traffic on one of Rio de Janeiro's busiest intersections. Then filmed the chaos. We were prompted by the sight of a young man whose plastic shopping bag split and sent a bottle of orangeade bouncing down granite steps adjacent to Queen Street. On our tour we used tangerines, splashes of bright colour spilling down the grey-brown steps. By using tangerines we could link the moment with Tangiers (the Interzone of William Burroughs' imaginary universe) and send the participants off without us for their own moments in Queen Street's Interzone.

• The extraordinary in the ordinary

There is a particular dynamic between materiality and immateriality. Take a piece of detritus from the street, or a can of abject booze, or a momentary juxtaposition of a dove and a white plastic bag and mould each of them, through an action, into an idea.

*(Following the ceremonial ribbon cutting and re-naming of Queen Street to Sardine Street, **Crab Man** collects up the tape and produces a tin of Special Brew, a strong lager, 9% alcohol.)*

Crab Man: Please take a discrete mouthful of the drink of the street. According to the sign over there, drinking the nigredo is illegal here, liable for a fine for £500, but this is carnival! Cheers.

(When every person has taken a sip, **Crab Man** *pours the remains of the lager over the large Crackington Formation rock. It froths.)*

Signpost: (sings)
At the bottom of the sea, at the bottom of the sea,
There is a memory, There is a memory
Layer upon layer of Earth's history
was presented to me,
At the bottom of the sea, at the bottom of the sea.

Crab Man: As the doves flew around the red tower, a white plastic bag, caught in the black branches of this tree, flapped like a ghost.

*(Signpost gives a tin of sardines to **Crab Man**.)*

Signpost: Here in the street, goods for sale mix with ghosts. In order to salt these goods and preserve these ghosts, and imitate the circulation of goods, Phil will circumambulate 'the island under threat' from planners who want to pull it down to prevent accidents.

*(**Crab Man** circumambulates the Clock Tower – anti-clockwise – through the traffic, around the roundabout and back to the pavement beside the rock from the Crackington Formation. **Crab Man** stops at the five points, raising the tin of sardines and shouts "Exeter Sardines to Nigeria!")*

- **Taxonomy of Space**

From your street you can build up your own categories of space and place. During our work in Queen Street and other sites we have developed a whole taxonomy of these categories. They work as short cuts to ideas, narratives and responses. They encourage us to see patterns and links within and between places. While there is much to be said for holding onto the recalcitrance and cussedness of specificity (in recognition of the

sheer material conservatism of things) we can always add the trajectories of space and – here – the generic links of its parts.

Categories might include 'Z Worlds' (apparently self-contained micro worlds), 'wormholes' (wrinkles in space that seem to connect you immediately to a far place) or 'almost place' (like a just-planted forest). (You can find other taxonomies of space on pages 203-7 of *Mythogeography,* Phil Smith (Triarchy, 2010) and in the paper "A Taxonomy On Its Toes", *Performance Research* 11 (1), 2006.

One of our categories was 'edgelands' – usually associated with porous urban boundaries, we found an 'edgeland' staginess and affordance in the abject spaces on our street:

*(Without any verbal instruction the **Crab Man** zig-zags to the edgeland along the 'cracks' in the pavement – the edges of pavement slabs – followed by the walkers. **Signpost** then invites them into the bushes that grow at the edge of the paved area.)*

Signpost: In Jennifer Jenkins' book *Remaking The Landscape*, Marion Shoard writes of edgelands: those places on the edge of cities that are neither urban nor rural, but abandoned void places, used by children as dangerous playgrounds or by people whose business is secret – Shoard calls them "the only theatre in which the real desires of real people can be expressed..."

*(**Crab Man** by now has gone to the far side of the 'edgeland' and climbs up onto it via the low wall, ready to help place anything in the 'edgeland'.)*

Signpost: We have made a theatre here. If you've brought anything with you to leave as a relic of your own walk, this is where we have been placing our relics – so please place your object in our edgeland playground – also, I've brought some ribbons to tie on the branches if anyone would like to do that – and feel free, anyone, to instruct Phil, as the **Crab Man**, to re-arrange this garden of earthly delights to express or satisfy a desire.

Crab Man: We leave things here and sometimes people take them away, sometimes they leave things. And sometimes they sleep here.

*(The **Signpost** and **Crab Man** each place an object of their own in the 'edgeland delights garden', then lead the walkers back to the zebra crossing.)*

- 'in the corner of the eye'

While one person is guiding you can create images or actions almost in the corners of the audience's eyes (these actions or images should complement or contradict what is being said to the audience or being acted out immediately in front of them).

Around the Clock Tower, early on in the tour, we both separately set off on circumambulations of the tower while the other one of us stayed with the group; adding to the sense of movement and 'nigredo'.

• Looking back

From the beginning of your tour you should be asking your fellow walkers to pay close attention to signs, to ironies in details, to textures, to the particular qualities of materials. So find a moment, perhaps around the halfway point in your journey (but it will depend on what spatial opportunities your site offers you) to turn around and look back over ground you have covered together. Encourage a different kind of looking. Rather than an immersive obsession with details (getting right into the cracks and the grain) this is a moment to offer something like a provisional 'story of your street' or a pattern of its patterns, a philosophy of its shapes and signs. To take your audience from the particular to the symbolic.

*(The **Crab Man** takes out a copy of H. G. Wells' 'World Brain'.)*

Crab Man: In ancient Greece, important buildings were expected to represent and symbolise a philosophy. Eighty years ago, H. G. Wells

dreamed of a world brain, its synapses repre-
sented by an identical library in every city in the
world, so that everyone might share in the same,
simple, accessible diversity.

Look back at the idea that you have just walked
through. The International Style of National
House, the old dole office. The architect Le
Corbusier described functional modernism
as the alternative to irrational revolution. In
the telephone exchange the functionalism
overcomes all formalism; those strange corner
windows are machine gun positions for defence
against the irrationalities that our betters feared
in the 1960s and 70s. And do you see the sharks'
teeth and do you see your own twenty minute
ghosts down there – the slightly different people
you were then.

Because this is a place of doubles – now turn
and look the other way. We are about to pass
between the two great towers of the city: on the
right the tower of St Michael the Archangel,
Hermes, Thoth, Mercury, pointing to the sky, a
gothic chisel striking in the heart of the heav-
ens. On the left, the tower of Athelstan, the relic
collector and ethnic cleanser, driver out of the
last of the Dumnonii, built on the remains of a
volcano. Let us step carefully across the void. To
the cholera!

(Walk to a point opposite Jenniflower.)

- **All the senses**

Challenge the dominance of looking and listening on your tour.

Touch: each other, the texture of walls, the props and relics.

Taste: drink together the drinks of the street (coffee, Carlsberg Special Brew, etc).

Smell...

We took our walkers into Jenniflower, the florist's. Partly for a moment of interaction with the staff there in their roles as facilitators of rites of passage. But also to plunge the walkers into the aroma of flowers. To shock them. To have a moment of transition from the mostly ignored smells of the street to the perfume of flowers and then back into the street.

• Spinning the yarn

Once you glean a strong idea from something on your street, experiment with ways of extending and developing it. Once it begins to move and change, try to draw in strands from other elements that you have discovered.

Outside the Co-op we found a set of oddly coloured paving slabs that were shaped as if for a game of hopscotch – as our participants arrived from their self-guided tangent we invited them to have a go and explained that the game originated as a means for training Roman soldiers to stay light on their feet in battle.

After a short demonstration of combat, we protested about the use made of ideas from exploratory and radical walking in military training (for example, the use made of situationist ideas in officer training for the Israeli Defence Force), and how on Exeter's streets the Royal Marines had their own covert *parcours* club. Citing the thought that when a new idea is adopted by the military it loses the last of its 'life' and that only experimentation can resist such incorporation, we all ran to the bridge experimenting with different moves as we went.

• Missing things

Look out for and point out those things on your street that have left the marks of their disappearance, and that disappear during the time that you are preparing and performing your tours. And when things do disappear, look to see if that has led to the reappearance of something else. When treasured things and useful markers are suddenly gone you may feel a little bereft, but their absence can be a feature in itself, the gap left can be a space for storytelling or a stage upon which to leave a memorial.

Numerous things disappeared in the time we were preparing our tour: a memorial to railway

dogs 'Ginger' and 'Nigger', hidden for years in bushes and revealed when branches were cleared, was ripped down, presumably by an anti-racist.

A window display in the shopfront of a divorce lawyers had dummies dressed in various costumes and represented relationship breakdown; it became for us an 'alchemical wedding' – unfortunately, we think we precipitated its removal when we bought some flowers from Jenniflower for the dummy-couple. (There's a warning here – over-enthusiastic engagement with the street can tip into clumsiness; be careful who you share your precious ironies with.)

Outside the Happitot shop (for children's toys and clothes) was an advertising sign that seemed to depict a child reaching through a wall into a void (a cue to discuss dark matter). This sign was taken down when the shop moved, but a subsequent refit revealed a 1930s railway ticket office emerging from behind Happitot's décor.

• Affordances

Use any accidental symbols or unintended stages that your route offers to you.

In the Sardine Street Tour we used zebra crossings as alchemical stages, calling out "Nigredo! Albedo!" as we passed over the black and white stripes.

• Spontaneity

Be ready to respond in the moment. When we've spoken with audiences who have come on our tours and walks, again and again they refer to unplanned events and our responses to them as the most memorable moments. So, be ready to accept accidents and unforeseen events (other than physical injury) as opportunities to be grasped rather than problems to be dealt with, solved, ignored or covered over. Without being too contrived you should try to integrate such

moments into the 'argument' of your tour. And if the moment contradicts that 'argument' then admit that too. Your tour is not so much a performance as an exemplary way of exploring – and for it to work like that you need to show that it makes you more open and able to enjoy the accidents of the street.

*(**Signpost** leads the walkers a few metres along the pavement. Draws a chalk line around one foot and then tells the story of 'the man who lost his sole'.)*

Signpost: One morning we saw a well-dressed man, an estate agent or an office worker perhaps on his way to an interview or a business meeting walking quickly along when the bottom of his shoe completely falls off, just here. And he received this tremendous shock as he felt the cold of the pavement. He picked up the sole and he went straight in to 'Inspirations' the handicraft shop there, perhaps to buy some glue. Can you please take off one of your shoes for a moment? *(Wait till all have taken off a shoe. We do too?)* Suddenly he was touching the ground, falling into it... as if the floor of the world had fallen away and he was plunging into a pit... he was in a panic... he had to get to a meeting, and we saw him look about desperately and then disappear into the shop... but his universe, for a moment, fell apart and was mostly empty space... put your

shoe back on and let's cross the road without falling through.

(Putting the shoes back on – or not perhaps - we cross over the road to the Rougemont Hotel.)

• Embrace coincidences

We have been teaching site-specific performance to students for many years now, so we have seen literally hundreds of such performances, often in vulnerable or busy places. We find it difficult to recall any instances where a well-prepared performance, open to and impregnated by its own site, has been upset by an unexpected event. (On the other hand, pieces that are impositions on their sites, or are attempts to seal themselves off from their sites, are often tripped up – quiet dialogues interrupted by express trains, Elizabethan melodramas unable to contain the arrival of Royal Naval helicopters.) We have no difficulty, however, in recalling instances where responsive pieces have been the recipient of happy coincidences: a police car pulling up at a performance of a crime-scene, a one-eyed man peering over the shoulder of a performer speaking about Nelson... stay open to your site (don't 'lose yourself' in portraying psychological characters or chain yourself to a fixed script) and you will also

be the recipient of happy coincidences. Be ready to receive them gratefully.

Outside the Royal Albert Memorial Museum, as Simon was describing the exploits of C. V. A. Peel, the big game hunter (and author of *The Ideal Island*) who shot many of the Museum's exhibits including the iconic 'Gerald The Giraffe' a man hurried past carrying a huge toy giraffe. At the sandstone and limestone tower, visited early on in our tour, parts of the sandstone figures (horses, dolphins, snakes) are beginning to crumble and we would find small fragments of the stone that had fallen away. But one day we found at the foot of the tower a complete sandstone horse's foot. This has become our most treasured relic: for the Clock Tower (called The Miles Clock Tower) was built as a memorial to William Miles, author of the influential *The Horse's Foot and How to Keep It Sound* (1846).

And talking of...

- **Relics**

The thrill of narratives and trajectories on your street, its dynamic events and its connections and commerce, can skew a tour into an uncritical celebration of its mobility and vivacity. We recommend that you collect some of the 'relics' of your street (objects

you find in the gutter, commodities that are
for sale there, mislaid notes) as hooks or
snags upon your accelerating progress. Let
the thingness (and sadness) of these objects
serve to exert a torque upon your perfor-
mance, to slow it down or twist it into reveal-
ing its own contradictions.

Our large golden-coloured box of 'relics' was a
burden that our participants had to carry, shar-
ing the load between them. Later in the tour
we compared our box with the sealed boxes of
the prophetess Joanna Southcott (in which she
placed her prophecies until they had come true)
and we processed our box to the Guildhall (just
off Queen Street) as Southcott and her sup-
porters had carried her sealed box (though not

through Marks and Spencer as we did). At the Guildhall the Southcott box had been unsealed and her writings given to her 'Seven Stars' – seven influential and wealthy supporters who were to help make Joanna Southcott a household name with over 100,000 'sealed' followers.

The objects in our box were ordinary, everyday items – trinkets from shops, lost toys, detritus from the gutter. But we found that the way to present these was not as a collection of mundane things, but as the quotidian equivalents of the hundreds of 'holy relics' collected at Exeter Cathedral (which is a few paces from the end of Queen Street) by emissaries of King Athelstan (including a piece of the Burning Bush and part of the Spear of Longinus).

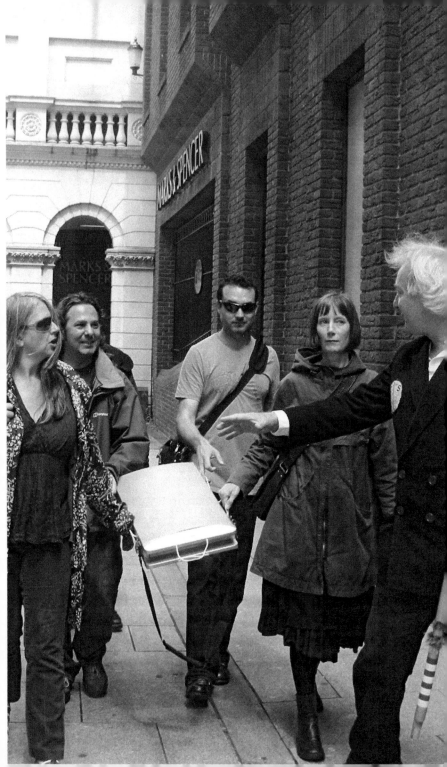

*"In site work the found object (the find)
indicates habitation, usage or past action
by others, animal or human, thus providing
evidence for (or markers of) time and
motion. The boot suggests travel, journey,
an unidentified person, an event that led
to abandonment and a process of change,
endings and abjection. Collecting and
removing such objects from a location might
be construed as malpractice, certainly with
regard to the ethics of industrial archaeology.
When is site-specific intervention an act of
plunder or 'tomb raiding' for art's sake? The
relic removed can in some cases be an act of
rescue or restoration. When the abject object is
transformed or re-animated, the artist could
certainly be regarded as someone who gives
a new value or significance to the discards by
salvaging memory and time."*

Simon Persighetti, 2001

• Developing patterns

**If you take time to develop your materials
then you will find that there are developing
patterns that you can weave into the trajectories of your tour.**

We found there was a developing pattern of
stars – first a five-pointed star (the five routes
leading from the Clock Tower), a six-pointed

star on a drain cover, then a design on a jeweller's in Gandy Street that combined five- and six-pointed stars and finally, under the two stars on the freemasons' temple, we gave the audience the role of Joanna Southcott's 'Seven Stars'. All the books we used to read from – *The Ideal Island*, *Spacetime Inn* and *World Brain* – were, coincidentally, coloured a bright orange.

• Folding back

Something that may help your participants to make connections from your small performative moments to bigger pictures is to make sure that some of the elements that you perform early on in your walk 'fold back' into the tour later.

Early on we quoted from the novel *The Ideal Island* to set up ideas of expedition and oppressive utopia. Later we introduced the walkers to its author and the role he played in our 'myth' of Sardine Street. About halfway along Queen Street we described how the street (long and straight) is often mistaken for one of the routes made by the Romans when Exeter was Isca Dumnoniorum and pointed out just how recently (in the mid-nineteenth century) it was made with bridges, infilling and the demolition of narrow mediaeval streets and yards. Later

we doglegged off Queen Street and were able (thanks to a local historian who came on one of the tours) to point out where a sharp corner on the remaining mediaeval road exactly follows a corner of the Roman fort.

Signpost: Let's look at the street from a different perspective. *(At the bottom of the granite steps pointing back up to the road.)* Do you see how when you look from here the street is not as natural as it seemed? It is more like a pier or a causeway built across a valley. And the Roman soldiers you might have imagined marching up and down its arrow-straight line can't ever have done that: this street was only begun in 1835.

Photo: Tamany Baker

• Farewell

Think about how you want to end your tour. Do you want to be available to your participants so you can discuss their responses with them? How can you use the moment of ending or farewell to continue and extend the dynamic of the tour?

Can you find an ending that is somewhere between the finality of a bow to applause and the conclusion of a conversation?

Usually at the end of a tour/performance we would want to stay around to chat with the audience, perhaps go for a drink or a meal together. But we came to feel that on this tour there were already many moments of dialogue with our participants and that we had fired at people a great deal of what we knew and what we are. That we should give the participants some room! Part of the intention of the Sardine Street Tour is that the people who come on it should feel that their formation into a group of walkers, their transformation from strangers into a gang of fellow-explorers, is as important as anything else about the Tour. So we contrived to 'disappear' suddenly into the street and leave the group, without prompting, to talk together, to drink together. And they always talked, and sometimes they went off to drink.

We had spoken for a moment of the illusion of the street:

Crab Man: This is a modernist street. Until very recently it was not a street at all – for right where we are standing, between Marks and Sparks and the Sports shop over there, was the Swan Tavern.

It had a large meeting room where performances were staged of recent colonial events. One day, the cannons used to portray some battle were loaded with a little too much gunpowder and they blew out all the windows, scattering horses through the streets and out into the suburbs.

Then, declaring that it was time for the two of us to go for a drink, we said our 'goodbyes', turned into the middle of the street and where the Swan Tavern had once stood we mimed opening and passing through its door before walking off, like old ghosts, back up the middle of Queen Street.

THE MYTH

From the very beginning of our tour we had framed our encounter with the everyday of our street within a utopian purpose: "for right here two dreadful utopias were conceived". We had excavated these utopias from the writings of the eighteenth century prophetess Joanna Southcott, who had worked as a servant in a house in Gandy Street (off Queen Street) during much of her prophesying, and from the travel writing and novelising of the hyper-racist animal-collector C. V. A. Peel. We told the stories of both Southcott and Peel as those of utopian trajectory; one a hunt in the African jungle that leads to the display of an elephant skin in Queen Street, the other an adventure of prophecy, fame and disaster.

Peel's story is contextualised by his fantasy novel *The Ideal Island* (1927) in which a racist-elitist utopia collapses. Southcott's dreams, later transcribed into doggerel (we recite an example early on in the tour), led her to a strange disgrace, which we re-enact in Gandy Street. Southcott lies dying, anxious to wed, believing she is pregnant with the messianic child Shiloh, our relics case doubling for the distended belly of her phantom pregnancy:

*(The **Crab Man** is wearing a tea towel as a scarf over his head, and a pinnie over the relics case for a pregnant belly. He speaks in a high-pitched Westcountry accent.*

(He leads the audience to stand beneath the five- and six-pointed stars on the Gandy Street entrance to the freemasons' temple.)

Crab Man: Although the prophecies of Joanna Southcott contain visions of the street today - the clock, the flying horses, the carousel of light in the clouds, the fearsome bulls, it is not the alchemical wedding missing from the window of Slee Blackwell Solicitors - the wedding of the sun and moon – that we're going to enact.

Signpost: (as Peel, wearing a large false moustache) No. It is a mythogeographical wedding.

Crab Man: Joanna Southcott longed to marry her Apple King – Pomme Roi - the Reverend Pomeroy – but he refused her – and so we're marrying her not to an Apple but to a Peel.

Signpost: Wedding the eighteenth to the twentieth century.

(Crab Man and Signpost join hands.)

Crab Man: And the fruit of this union is not, as Joanna hoped, a child "to rule the nations with a rod of iron", but rather as she herself admitted, as she died, with a mob hammering at her door:

Signpost: (Like birth cry.) "It is all a delusion!"

Crab Man: This is the 297th delusion of Sardine Street. Only 68 to go.

The utopias of both Southcott and Peel were anti-modernist ones; their shared delusion was their denial of a modern city. Southcott was

desperate to save the establishment from itself (and was vigorously rebuffed). Peel sought to reject modern society and yet when he came to imagine such an experiment he could only tell of its violence, contradictions and betrayal. Together, they constitute a vicious myth of Exeter, our city, as a rural 'county town', priding itself on provinciality and backwardness, a denial of its history as a sophisticated city: until its sidelining by the industrial revolution it was the fourth largest city in England. A denial of Queen Street's culture – of its cool and worldly neo-classicism (with hotel, railway station, college and legal chambers all in neo-classical styles) in the neo-gothic fantasy of its museum and the original gothic of its mediaeval Gandy Street (inspiration for J. K. Rowling's Diagon Alley). This nostalgia for a non-existent, simple, rural city has dogged Exeter until very recently when it has begun, slowly, to embrace greater diversity and cosmopolitanism.

Many people are surprised to find that this "historic city" has trashed so much of its historic architecture. (For if your picture of your past is an unreal one you have contrived, it is hard to value the real one before you.)

This was not the 'message' of our tour – many of the participants may not even have spotted this particular significance among the many symbols and actions. Its importance was in its weaving together and supporting disparate elements of the tour. It helped to structure the tour and generate a rising dramatic intensity as it moved towards its conclusion.

• Your myth

Find the myth of your street. The visceral and intense narrative that somehow evokes the unspoken and unresolved contradictions of the place you have chosen. Use the gradual unfolding of this myth to give a shape, a narrative and dramatic contour, to what might otherwise be the disparate accumulation of your fragments. Keep the fragments in their discrete and fragmented form, but around them weave the myth, so that your audience is repeatedly changing their way of receiving your tour.

And that's about it...

Of course, we could go on at even greater length about the joys of making tours and share with you many more experiences and a few more tips... but the only real life that there can be in this booklet is if it is used. Its true author is you.

We wish you happy accidents, coincidences, incidents and discoveries!

Signpost & Crab Man

March 2011, Exeter

Unfolding the Street: opening the box of relics

UNIVERSITY OF WOLVERHAMPTON
LEARNING & INFORMATION SERVICES

We would like to express our thanks to all those who participated in our walks, and to all those who walk, travel, trade, traverse and work on Queen Street in the city of Exeter, Devon (UK).

The Sardine Street civic-ritual devices and costumes were designed by our friend and colleague Tony Weaver.

Photographs: Simon Persighetti
With additional images by Tamany Baker (see individual photo credits). www.tamany.net

The project was financially supported by grants from:

Exeter Arts Council (supported by Exeter City Council) and by the University of Plymouth

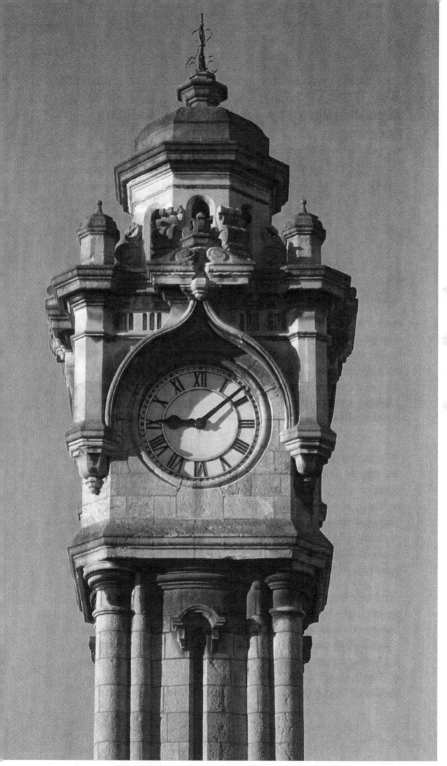

Also from Triarchy Press:
Mythogeography – A Guide to Walking Sideways

"Exeter-based performance artist Phil Smith is a veteran sideways walker and in this book develops psychogeography into mythogeography. It's a compendium of walking stories, hoaxes and digressions, lists, literary jokes, observations and dense passages of prose poetry-cum-theory."

Walk – Magazine of The Ramblers

"Footnotes, rather than remaining confined to their ghettoes, interrupt and swamp the main text, sometimes for pages at a time. The endnotes appear halfway through, and two thirds of the book is devoted to front and back matter (a joke about inflamed appendices suggests itself here). This text is dense with signposts, and… it invites diversion, digression, a kind of textual drift on the part of the reader. And of course drifting is at the heart of it. Mythogeography is cultivar or hybrid of Psychogeography… and the dérive is the basic template for many of the activities described in this book."

an – Artists' Networks

"The reach is wide and deep, occasionally idiosyncratic. The fragmentary and slippery format recognises the disparate, loosely interwoven and rapidly evolving uses of walking today: as art, as exploration, as urban resistance, as activism, as an ambulatory practice of geography, as meditation, as performance, as dissident mapping, as subversion of and rejoicing in the everyday. Mythogeography is a celebration of that interweaving, its contradictions and complementarities, and a handbook for those who want to be part of it." **Walking Home to 50**

"This polyphonic and visually-arresting manifesto practices what it preaches, offering photographs, diagrams, taxonomies, glossaries and found texts including a 'footsteps' narrative written in the third person regarding 'The Crab Man' who walked from Manchester to Northampton looking for trees planted by Charles Hurst, the acorn-casting author of **The Book of the English Oak** *(1911)."*

Studies in Travel Writing - Nottingham Trent University

Two more titles from Triarchy Press by Phil Smith:

A **Counter-Tourism Pocketbook: 50 Things to Do in a Heritage Site**

Counter-Tourism: The Handbook

www.triarchypress.com/soma